RUSSIAN FOLK MOTIFS

PETER LINENTHAL

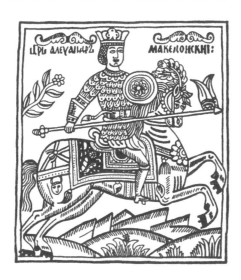

DOVER PUBLICATIONS, INC.
Mineola, New York

Bibliographical Note

Russian Folk Motifs is a new work, first published by Dover Publications, Inc., in 1998.

DOVER *Pictorial Archive* SERIES

Library of Congress Cataloging-in-Publication Data

Linenthal, Peter.
 Russian folk motifs / Peter Linenthal.
 p. cm. — (Dover pictorial archive series)
 ISBN-13: 978-0-486-40275-8 (pbk.)
 ISBN-10: 0-486-40275-4 (pbk.)
 1. Decoration and ornament—Russia—Themes, motives. 2. Folk art—Russia—Themes, motives. I. Title. II. Series.

NK1456.A1L56 1998
745'.0947—dc21

 98-34138
 CIP

Manufactured in the United States by RR Donnelley
40275408 2015
www.doverpublications.com

PUBLISHER'S NOTE

Russian folk art springs from the life and traditions of the Slavic peoples who have lived in eastern Europe for thousands of years. The Eastern Slavs are now the predominant populations in three of the five nations covered in this book—Russia, Belarus (Belorussia), and Ukraine—and have had a strong cultural and political influence on the other two—Georgia and Moldova (Moldavia). Living in the borderlands between Europe and Asia, and with Turkey and the Islamic Middle East to their south, the Slavic peasants have absorbed influences from many diverse cultures. Indeed, what has made Russian folk art such an interesting and popular genre is its incorporation of these elements from both East and West. The Slavs' conversion to Christianity, beginning in the 10th century, and the invasions by Mongols and others from Asia in the 13th and 14th centuries had lasting effects on eastern Europe. Then the great "gathering of the Russian lands," begun by Ivan the Great and consolidated by his grandson Ivan the Terrible, brought not only unity but also a Western, Christian orientation to Russia that has persisted through the 20th century.

Even with this political unity, the many and disparate regions of the Russian Empire continued to nurture their own local cultures. In folk art, the bone carvers of the north, the rug-makers of the south, and the artists of the Russian steppes have practiced their traditional art forms in much the same way as their forebears. The people have carved, painted, and otherwise decorated almost everything they made. Each piece was unique. Peasant artists, with their fertile imaginations and remarkable ability to improvise on age-old themes, seldom produced exact duplicates of what they had made before. The 228 illustrations in this book represent a select sampling of the work that is available.

The Slavic love of imagery is reflected in a number of the familiar motifs that were favored by Russian folk artists. Flowers, leaves, luxuriant foliage, fruits, animals (especially birds), and other elements, realistic and fantastic, were often combined in arabesques of great beauty. Geometric motifs were also commonly used—lozenges, rosettes, and stripes as well as triangles, circles, hexagons, and other common shapes. Human figures were also portrayed, often on stove tiles, where there was room to tell a story. Other subjects were characters from folklore like Baba-Yaga the ogress and Siri, a bird with the head of a woman, who lured travelers to their doom by her seductive songs. The Tree of Life, an age-old representation of life originating in the earth, was also a favorite motif.

Among the most popular items to decorate were Easter eggs, colorful symbols of fertility. They held an important place in virtually every household, especially in Ukraine. Although of pagan origin, dating back to Egypt and other ancient civilizations, these eggs were closely linked with Eastern Orthodox religious observances. Other objects illustrated in this book that show the connection between the Church and folk art are altar screens, portraits of saints, and architectural motifs on churches and monasteries. The scenes depicted in woodcuts, called *lubki* in Russian, often told a religious story, especially in the period when this technique first reached the Russian Empire,

in the 17th century. Important secular folk art objects are toys, especially the Matryoshka nested dolls and all kinds of figures carved from wood or made of clay. Carpets are important, too, both for their beauty and color and for the clear indications their designs offer of the Asian and Byzantine influences on Russian folk art.

Note: In the captions on pages 5–45, all places not otherwise identified are in Russia. Some places are small and may not be familiar to non-Russian readers. Among the villages noted for folk art are: Khokhloma, on the Volga River in the Gorky region, which is known for a colorful style of painting; Gzhel, near Moscow, a center of porcelain manufacturing; and the northern towns of Vologda and Olonets, important in the making of textiles. Also in the captions, Caucasus is taken to mean the mountainous region between the Black and Caspian seas.

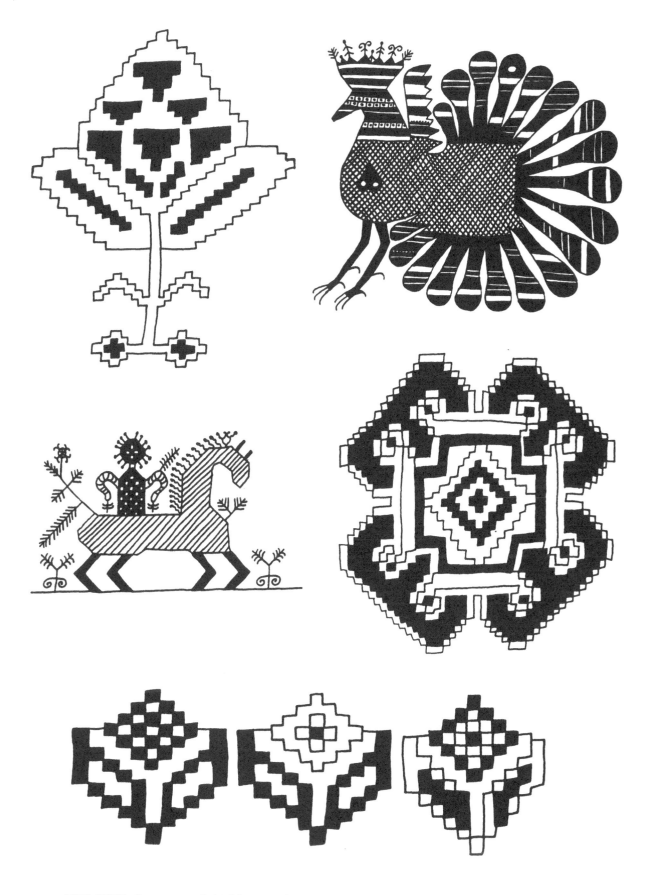

TOP, LEFT: Carpet motif, **Moldova, 19th century.** TOP, RIGHT: Embroidered towel motif, **Yaroslavl, 19th century.** MIDDLE, LEFT: Embroidered sheet motif, Archangel, 19th century. MIDDLE, RIGHT: Carpet motif, Moldova, 19th century. BOTTOM: Carpet motif, Moldova, 19th century.

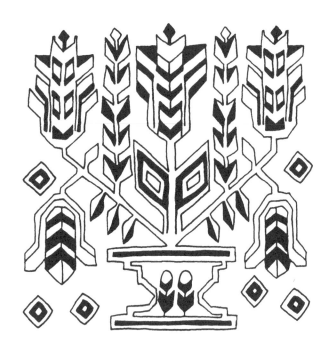
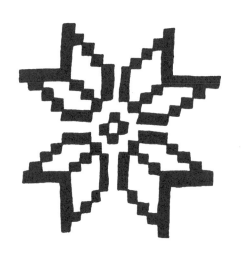
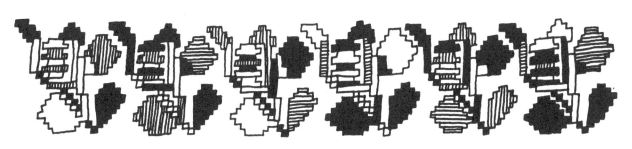
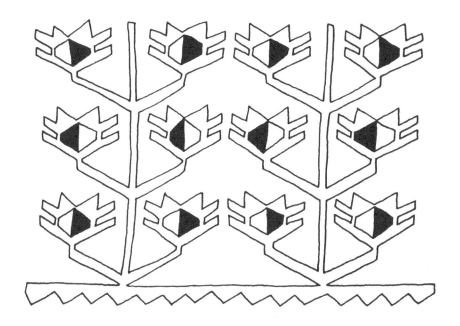

Carpet motifs, Moldova, 18th–19th centuries.

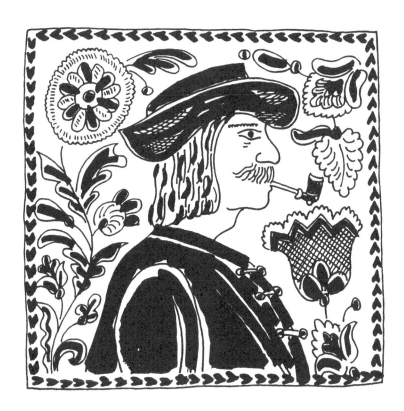

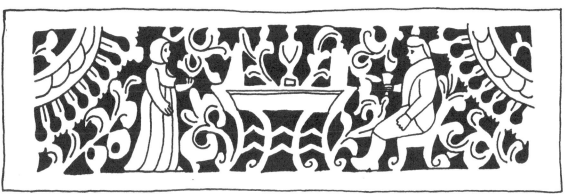

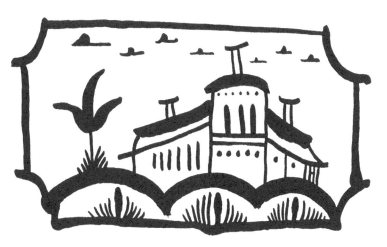

TOP: Stove tile motif, Ukraine, 19th century. MIDDLE: bone comb motif, 18th century. BOTTOM: Stove tile motif, Moscow, 18th century.

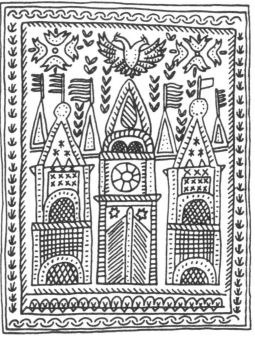
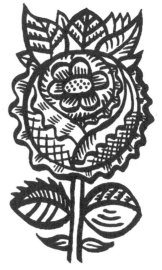
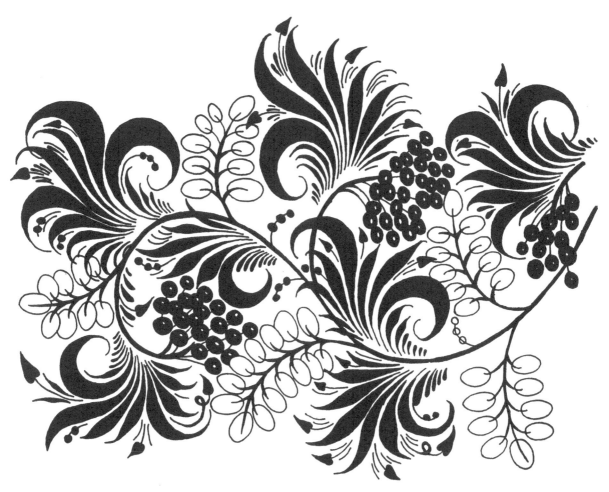

TOP, LEFT: Tile motif, Moscow, 19th century. TOP, MIDDLE: Ceremonial gingerbread mold, 18th century. TOP, RIGHT: Porcelain motif, St. Petersburg, 20th century. BOTTOM: Painted panel, Khokhloma, 20th century.

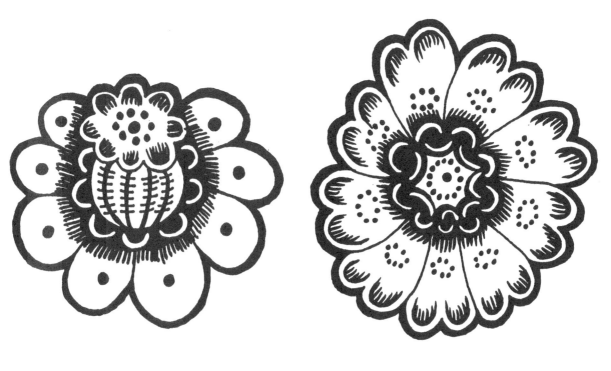

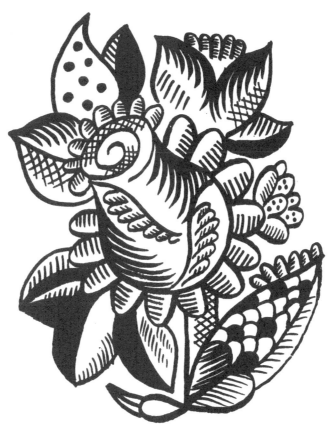

TOP: Painted decorative motifs, Khokhloma, 20th century. BOTTOM: Porcelain motif, St. Petersburg, 20th century.

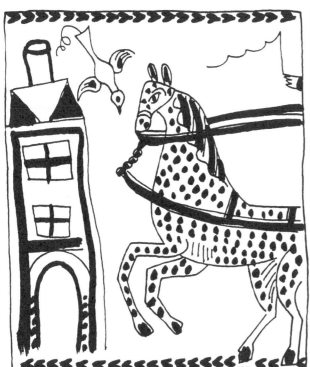
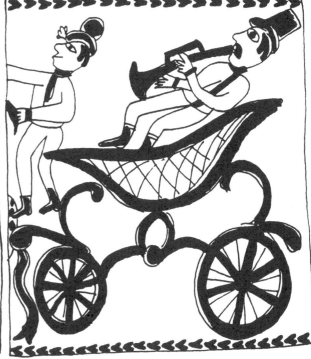
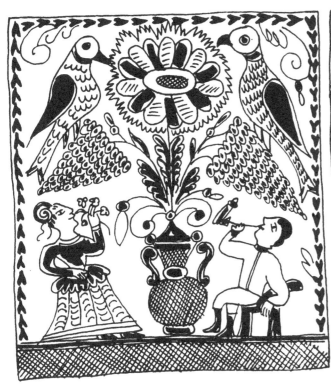
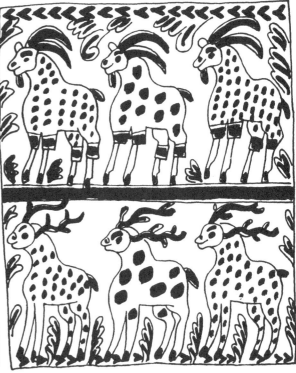

Stove tile motifs, Ukraine, 19th century.

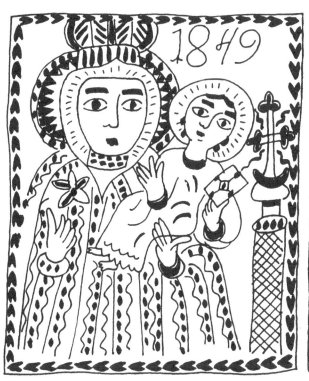
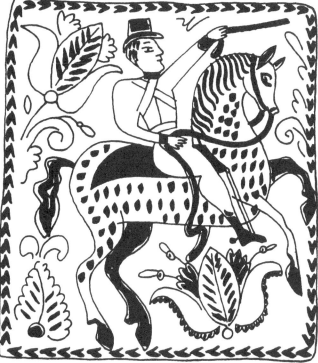
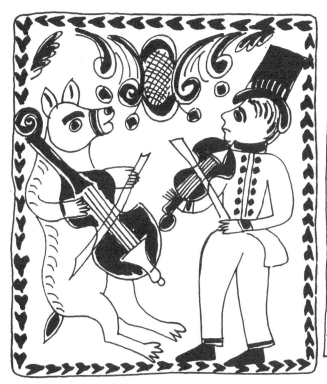
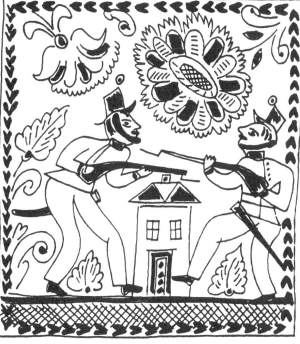

Stove tile motifs, Ukraine, 19th century.

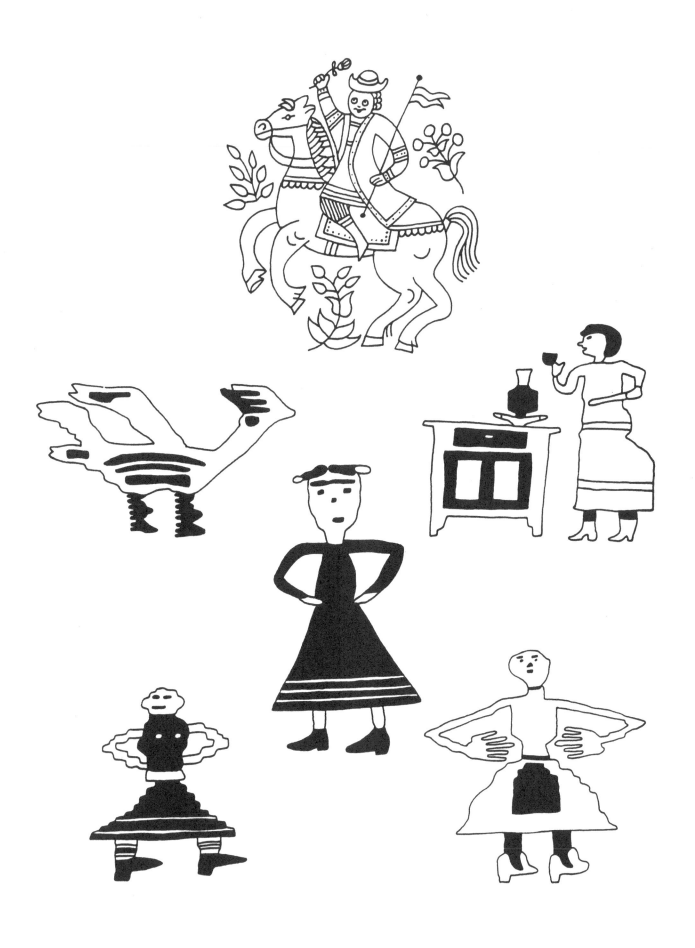

TOP: Painted curtain motif, 18th century. MIDDLE AND BOTTOM: Carpet motifs, Moldova, 19th-20th centuries.

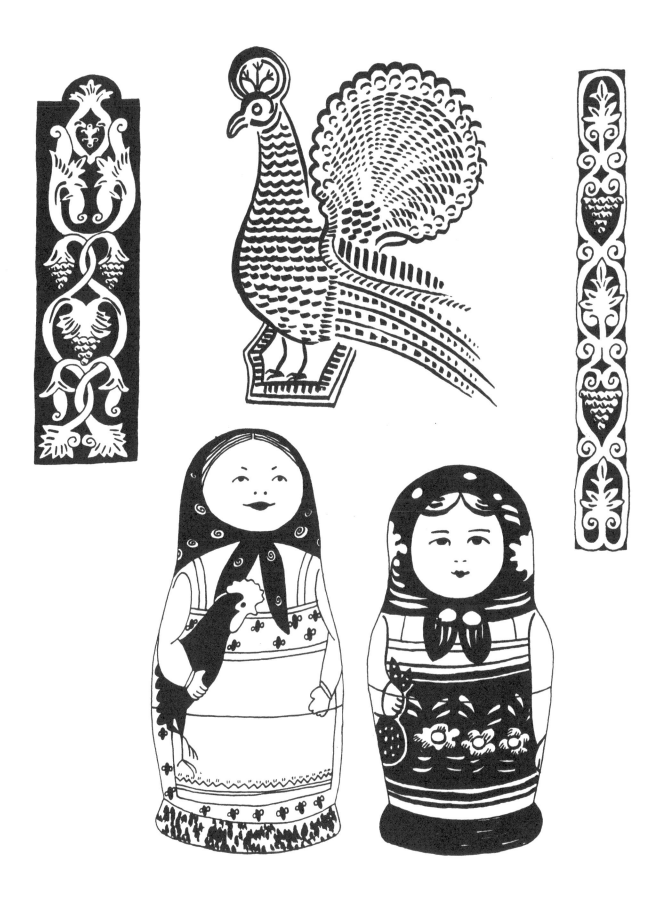

TOP, LEFT: Carved architectural motif, Novgorod, 19th century. TOP, MIDDLE: Gingerbread mold, 19th century. TOP, RIGHT: Carved architectural motif, Novgorod, 19th century. BOTTOM: Matryoshka dolls, 19th century.

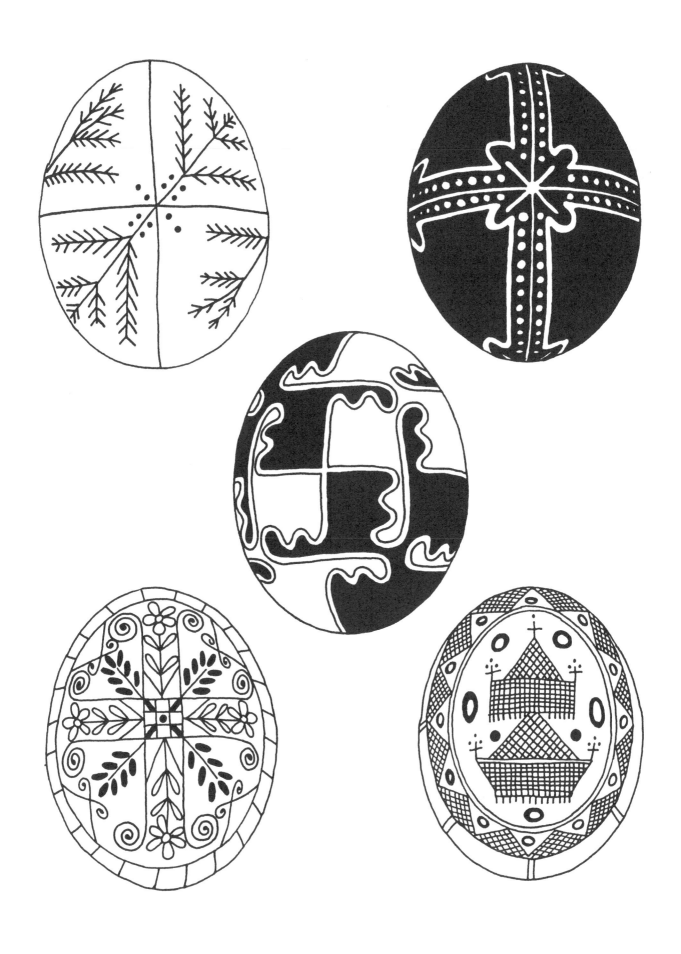

Easter egg motifs, Ukraine: TOP, LEFT: "Pine Trees." TOP, RIGHT: untitled. MIDDLE: "Gypsy Road." BOTTOM, LEFT: "Paska." BOTTOM, RIGHT: "Churches."

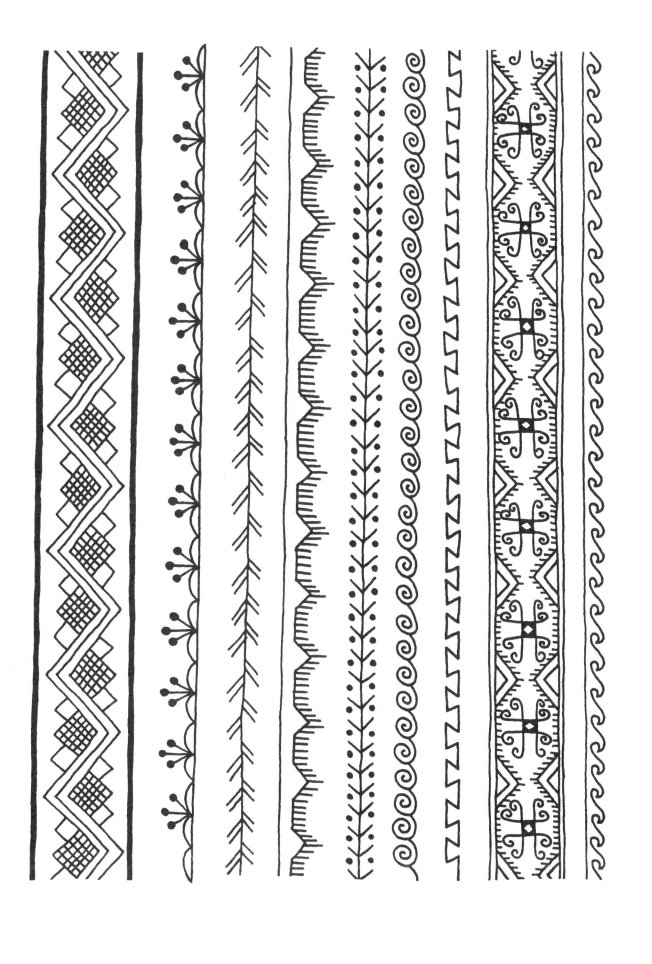

Easter egg motifs, Ukraine.

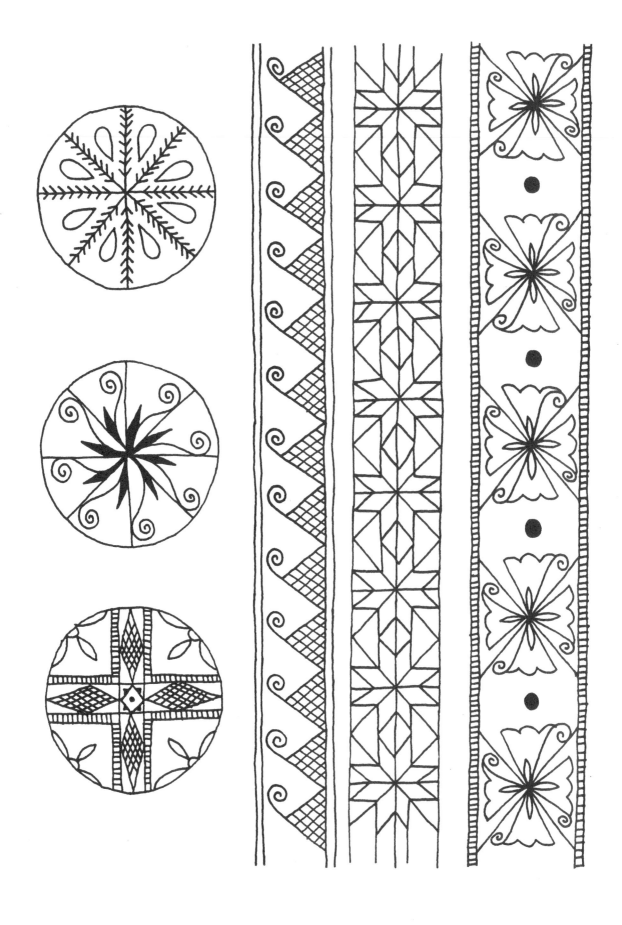

Easter egg motifs, Ukraine.

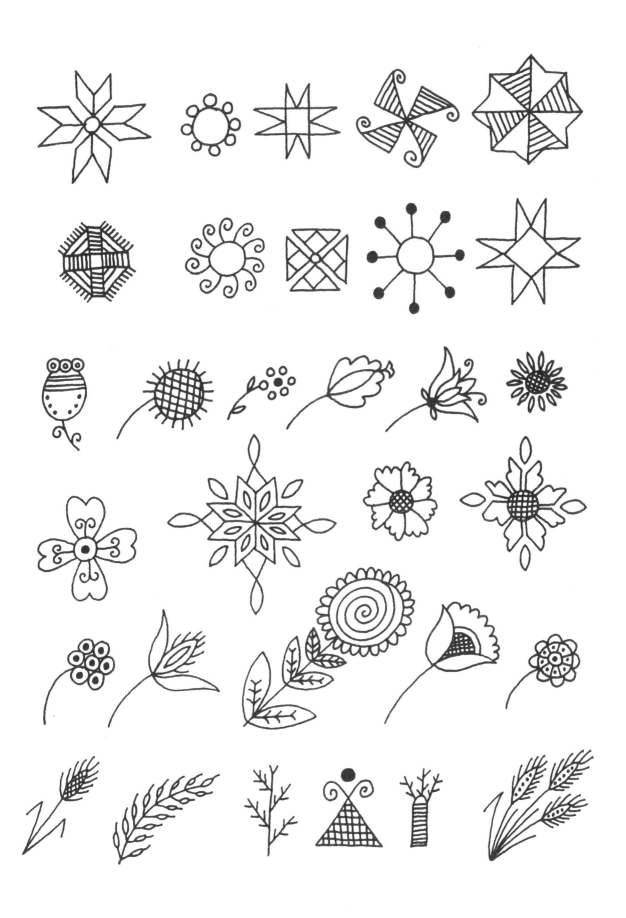

Easter egg motifs, Ukraine.

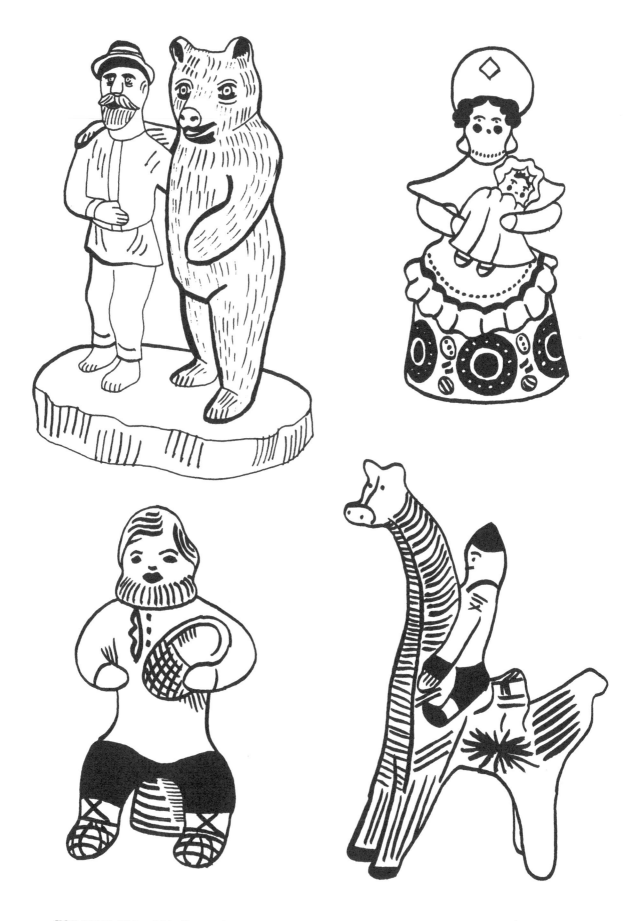

TOP, LEFT: "Friendship," carved wooden toy, 20th century. TOP, RIGHT: Clay toy, Kirov, 20th century. BOTTOM, LEFT: Clay toy, Archangel, 20th century. BOTTOM, RIGHT: Clay toy, Tula, 20th century.

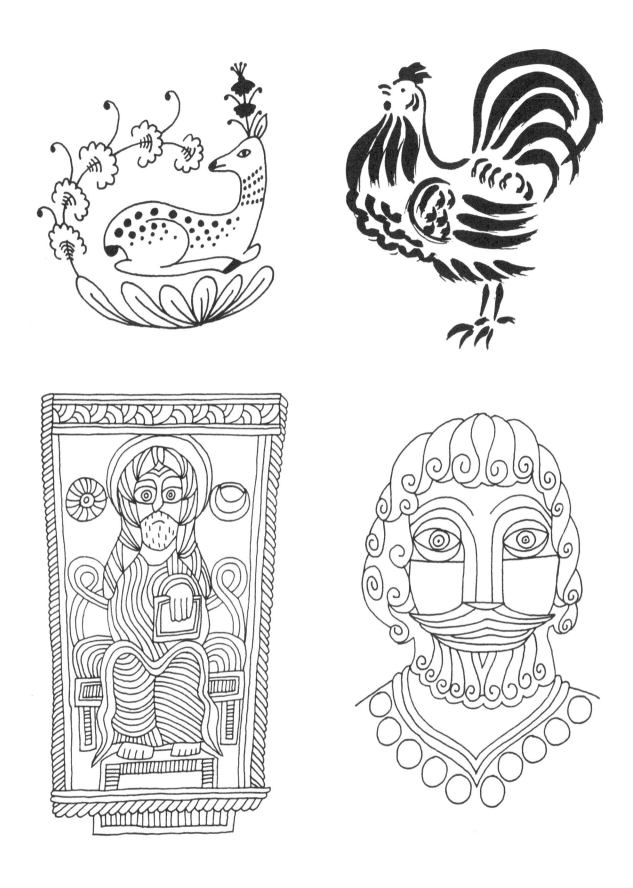

TOP: Ceramic motifs, Gzhel, 20th century. BOTTOM, LEFT: Stone relief, votive monument, Georgia, 6th century. BOTTOM, RIGHT: Head of Adarnese, Georgia, 6th century.

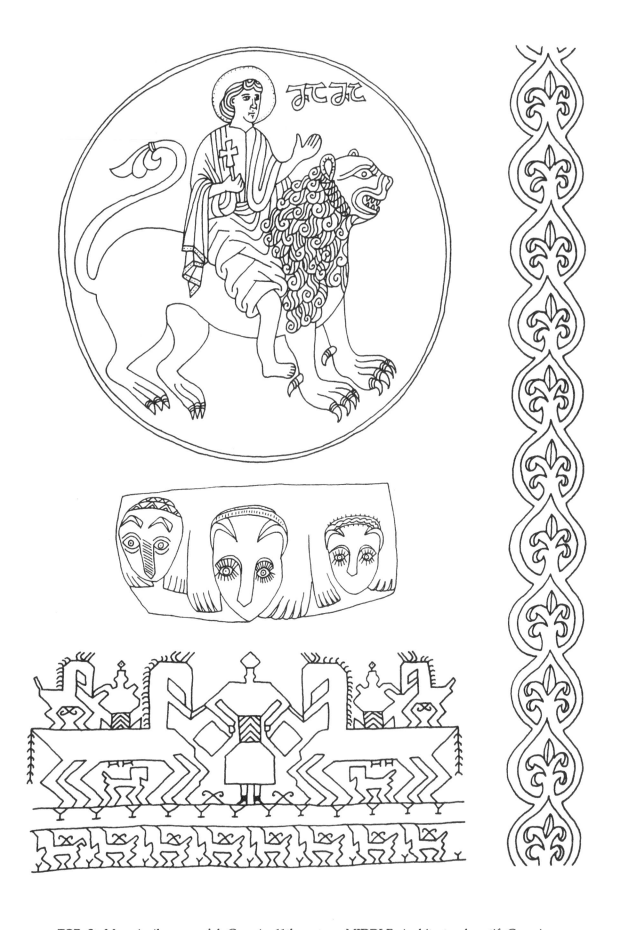

TOP: St. Mamai, silver roundel, Georgia, 11th century. MIDDLE: Architectural motif, Georgia, 10th century. BOTTOM: Embroidered motif, Olonets, 19th century. RIGHT: architectural motif, Georgia, 10th century.

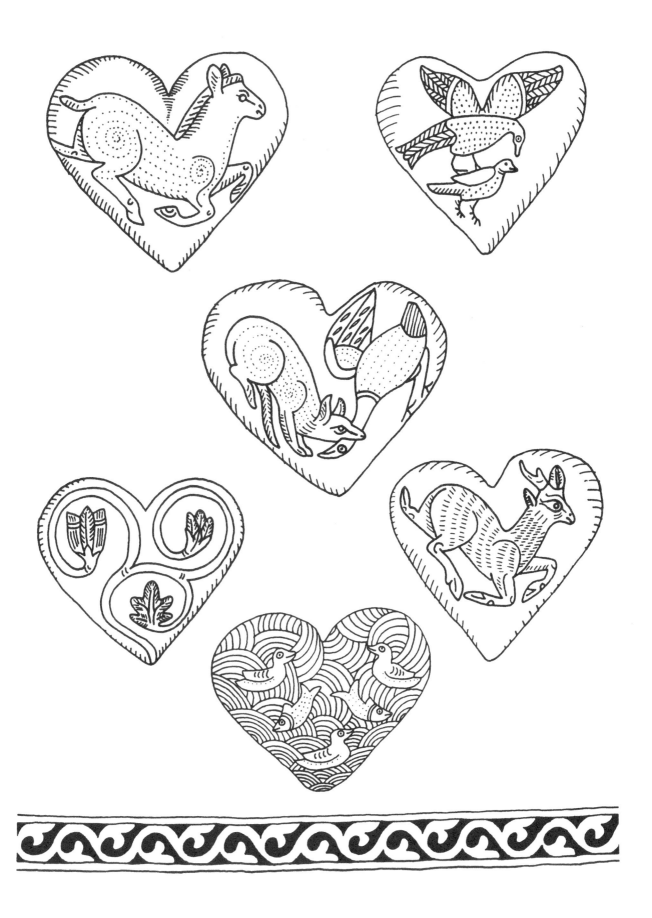

Heart-shaped metalwork motifs, Caucasus, 4th–9th centuries. BOTTOM: Architectural motif, Georgia, 3rd century.

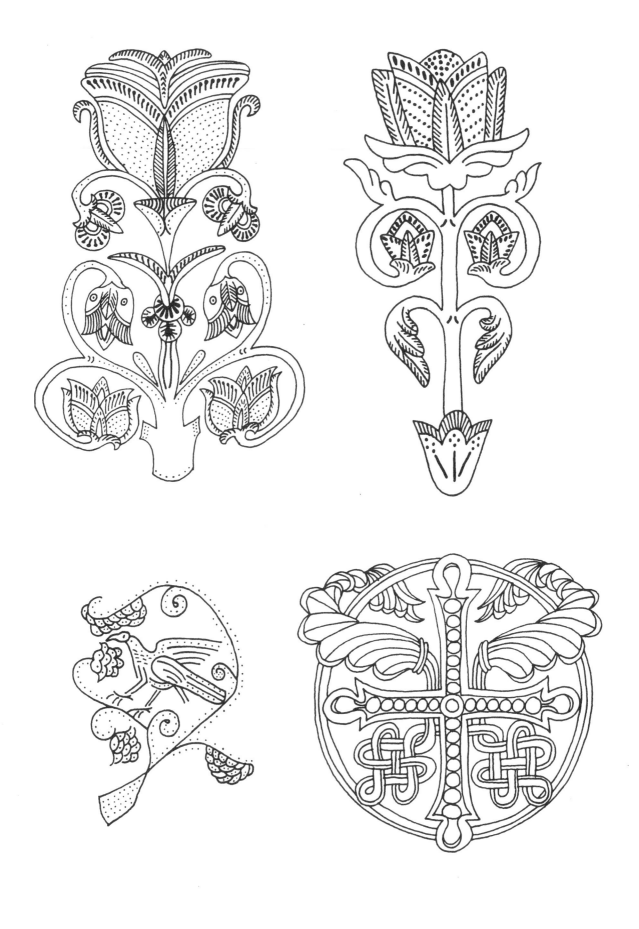

TOP: Metalwork motifs, Caucasus, 4th–9th centuries. BOTTOM, LEFT: Decorative motif, Nikitniki, 17th century. BOTTOM, RIGHT: Architectural motif, Georgia, 11th century.

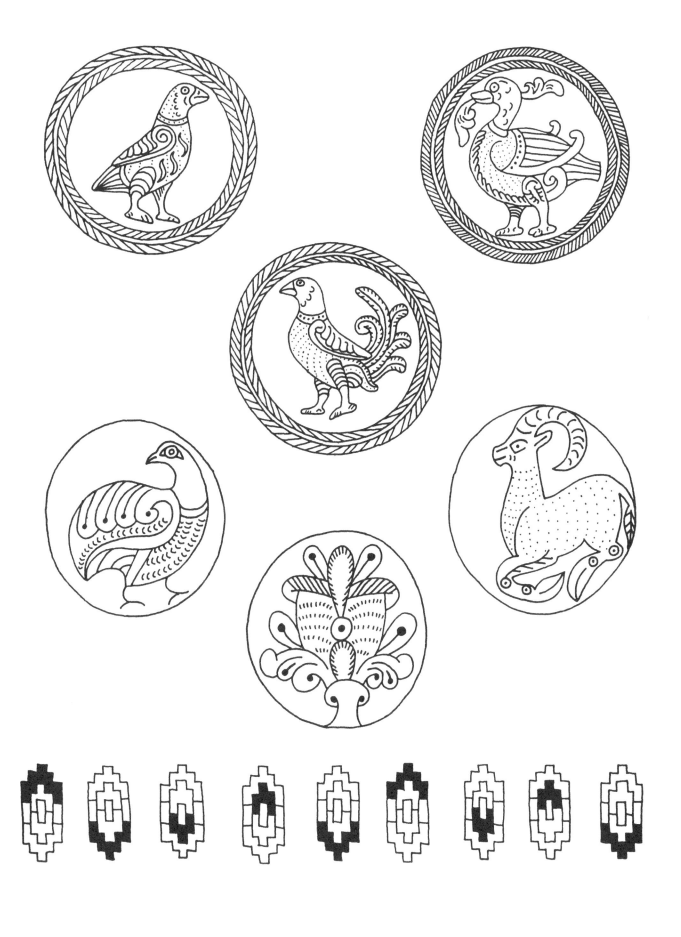

Round metalwork motifs, Caucasus, 4th–9th centuries. BOTTOM: Carpet motif, Moldova, 19th century.

ROWS 1–3: Embroidered pillowcase motifs, Moldova, 20th century. ROW 4: Carved wood motif, Georgia, 11th century. ROWS 5–6: Architectural motifs, Georgia, 3rd century. ROW 7: Cornice motif, Georgia, 11th century.

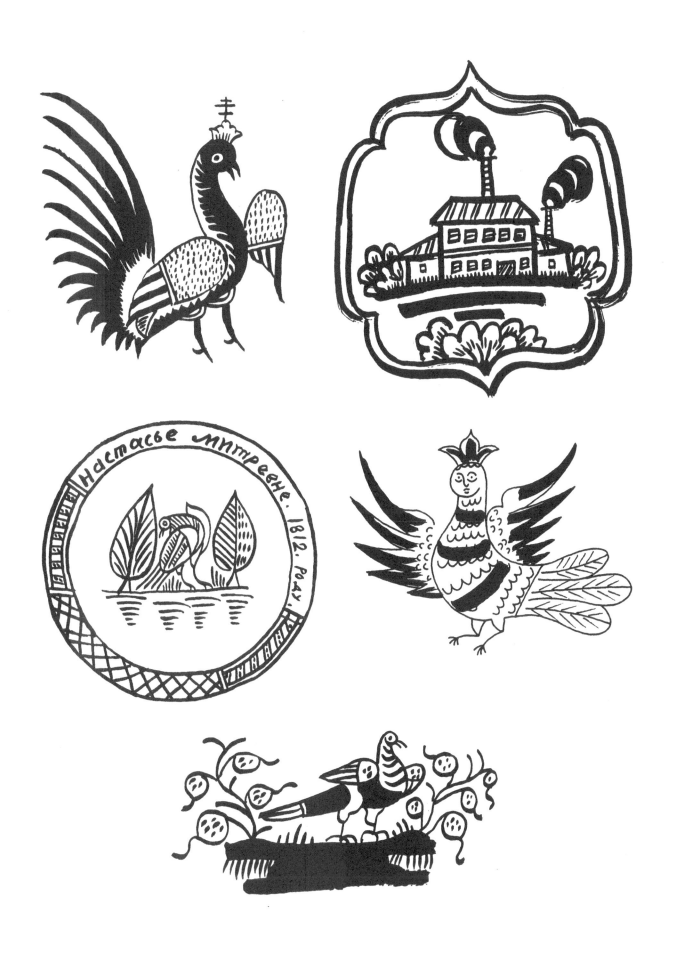

Ceramic motifs, Gzhel, 18th–20th centuries. MIDDLE, RIGHT: "Siri Bird."

TOP: Ceramic motif, Gzhel, 18th century. MIDDLE, LEFT: Painted motif, Khokhloma, 19th century. MIDDLE, RIGHT: Ceramic motif, Gzhel, 20th century. BOTTOM: Ceramic motif, Gzhel, 18th century.

TOP, LEFT: Ceramic motif, Gzhel, 20th century. TOP, MIDDLE: Carpet motif, Moldova, 19th century. TOP, RIGHT: Carpet motif, Moldova, 20th century. BOTTOM: Three ceramic motifs, Gzhel, 18th–19th centuries.

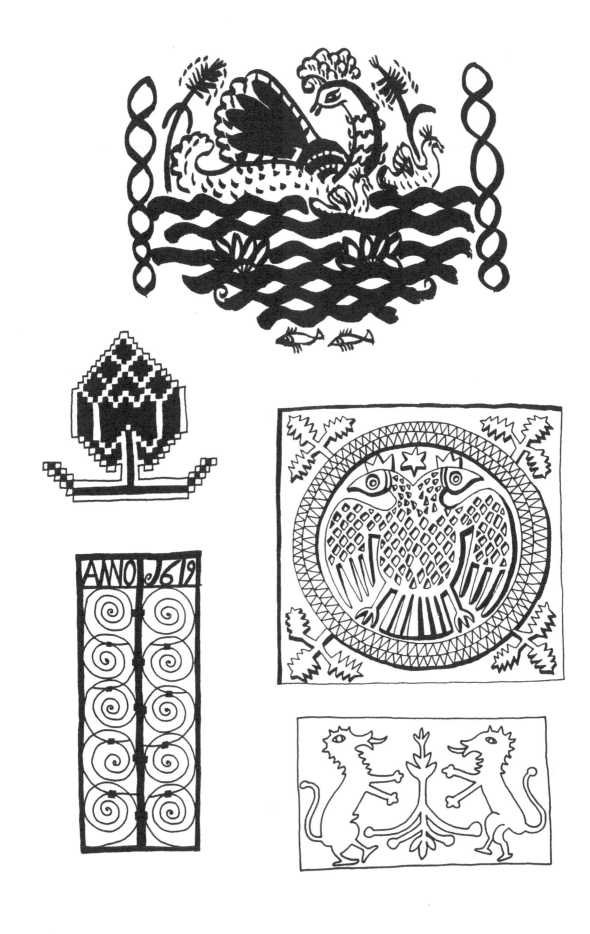

TOP: Ceramic motif, Gzhel, 20th century. MIDDLE, LEFT: Carpet motif, Moldova, 19th century. MIDDLE, RIGHT: Tile motif, Moscow, 16th century. BOTTOM, LEFT: Iron grill, Minsk, Belarus, 17th century. BOTTOM, RIGHT: Tile motif, Mir, 17th century.

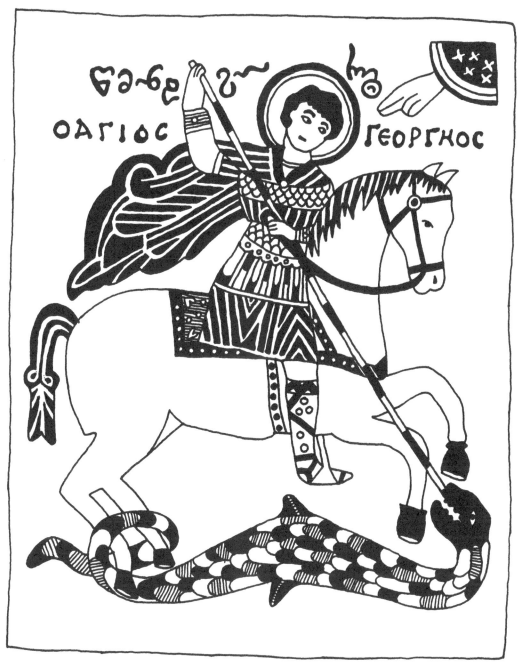

TOP: St. George, Cloisonné, Georgia, 16th century. BOTTOM, LEFT: Embroidered motif, 19th century. BOTTOM, RIGHT: Carpet motif, Moldova, 20th century.

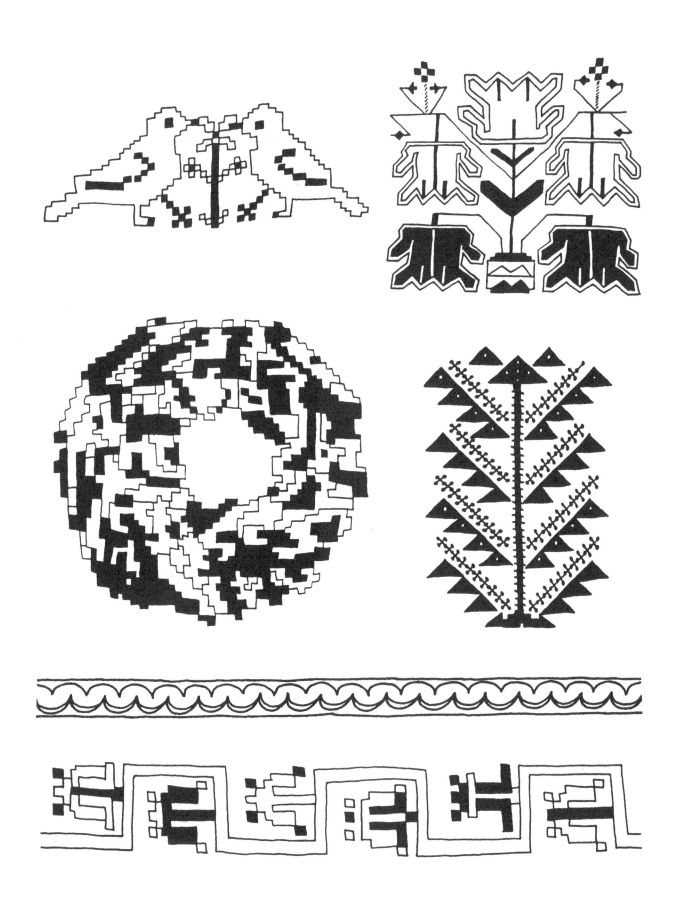

ROWS 1–2: Carpet motifs, Moldova, 19th-20th centuries. ROW 3: Architectural motif, Georgia, 6th century. ROW 4: Carpet motif, Moldova, 19th century.

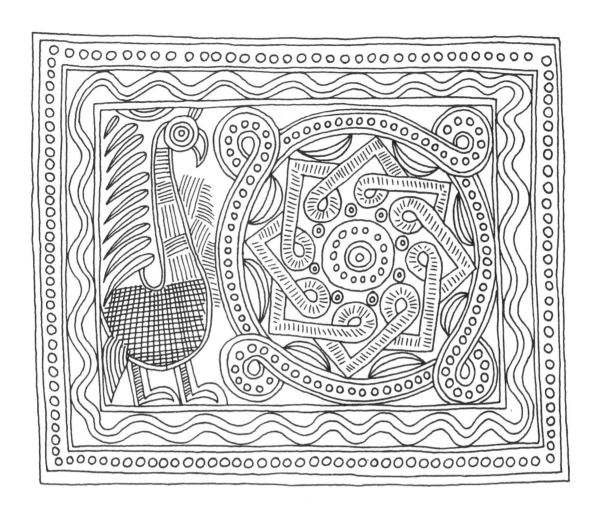

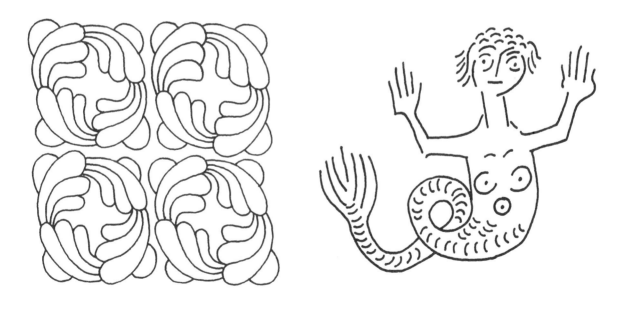

TOP: Stone relief, altar screen, Georgia, 8th century. BOTTOM, LEFT: Architectural motif, Georgia, 10th century. BOTTOM, RIGHT: Decorative motif, Nikitniki, 17th century.

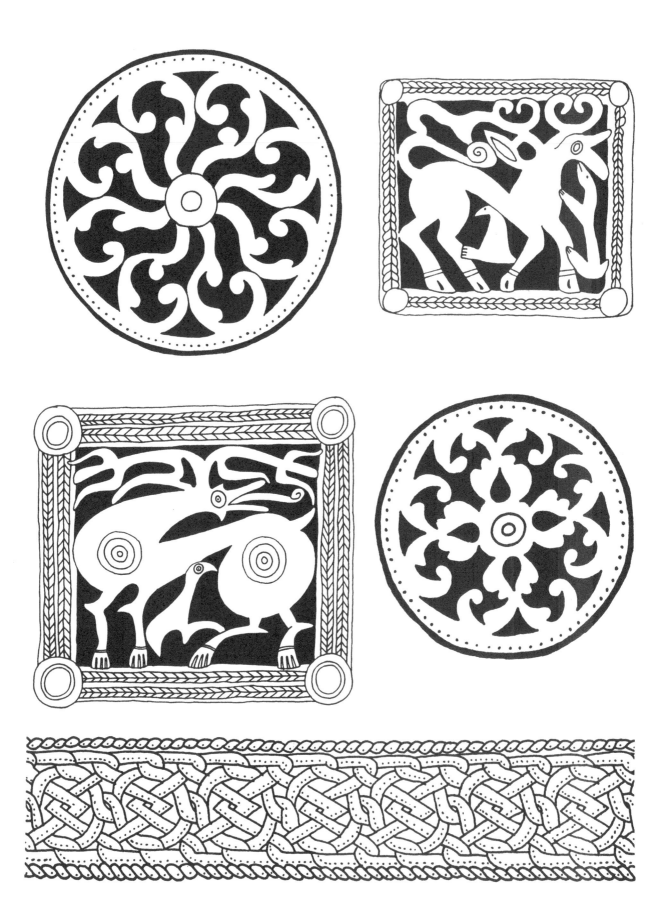

TOP, LEFT: Decorative motif, bronze door, Nikitniki, 17th century. TOP, RIGHT: Bronze buckle, Georgia, 1st century B.C.–1st century A.D. MIDDLE, LEFT: Bronze buckle, Georgia, 2nd–3rd centuries. MIDDLE, RIGHT: Decorative motif, bronze door, Nikitniki, 17th century. BOTTOM: Architectural motif, Georgia, 12th century.

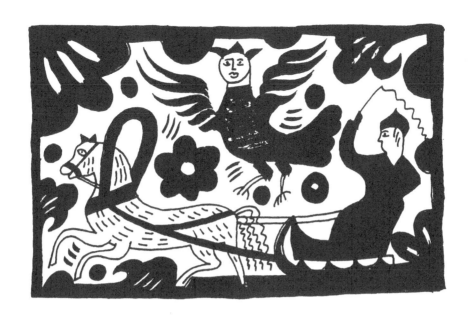

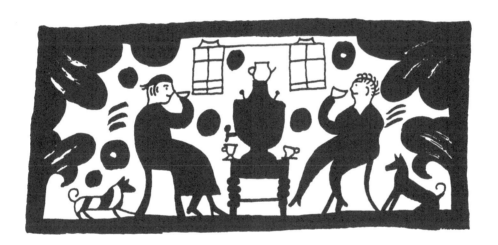

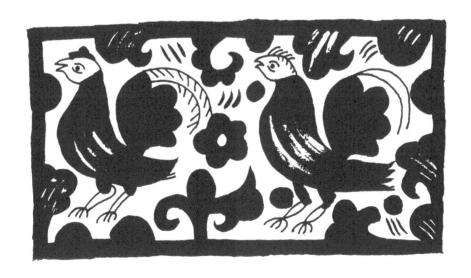

Motifs painted on a shuttle used in weaving, 19th century.

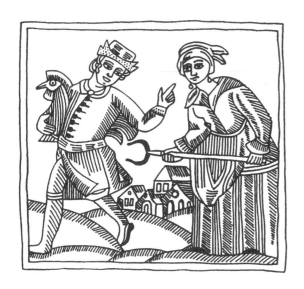

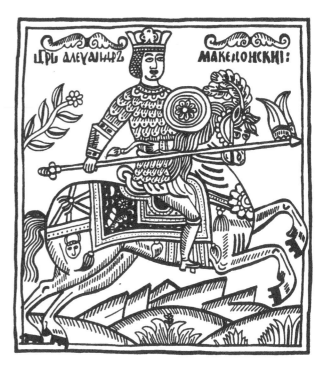

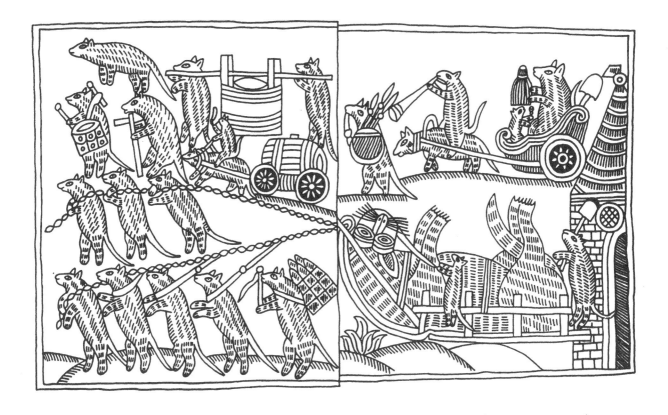

TOP, LEFT: "The Robber Comes in the Heart," woodcut, 18th century. TOP, RIGHT: "Czar Alexander of Macedonia" (Alexander the Great), woodcut, 18th century. BOTTOM: "How the Mice Buried the Cat," woodcut, 18th century.

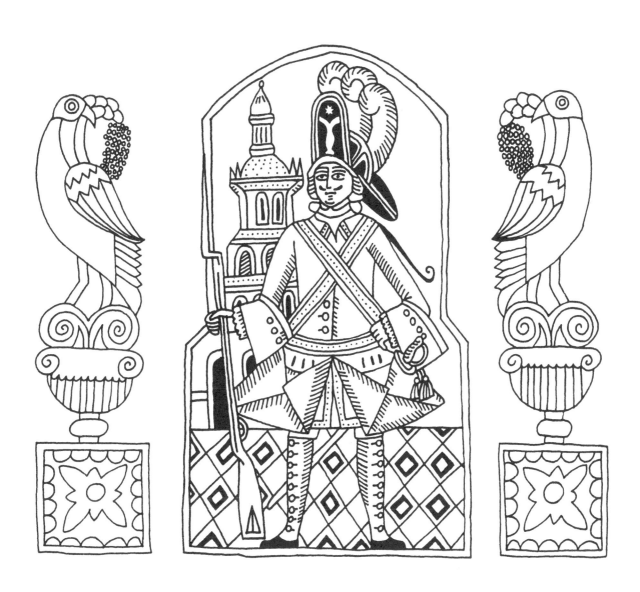

TOP, LEFT AND RIGHT: Architectural motifs, Novgorod, 19th century, TOP, MIDDLE: "Grenadier," woodcut, 18th century. BOTTOM: Embroidered motif, Vologda, 18th century.

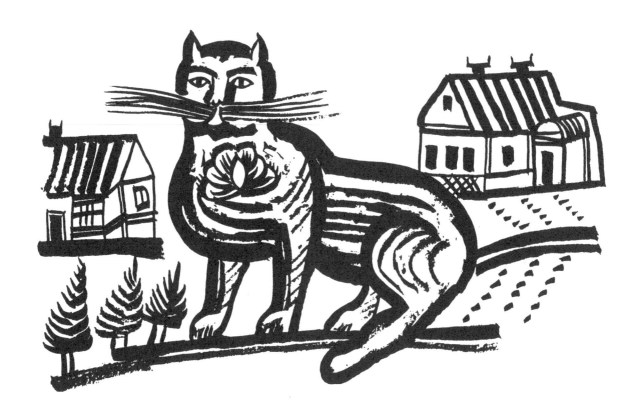

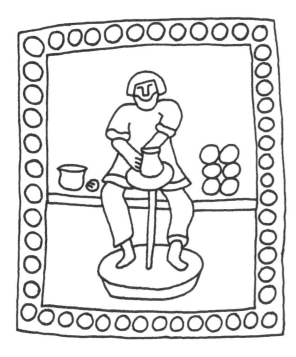

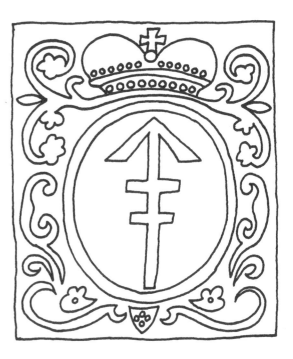

TOP: Ceramic motif, Gzhel, 20th century. BOTTOM, LEFT: Tile motif, Mogilev (Mahilou), Belarus, 18th century. BOTTOM, RIGHT: "Fox" coat of arms, tile motif, Zaslavl, 17th century.

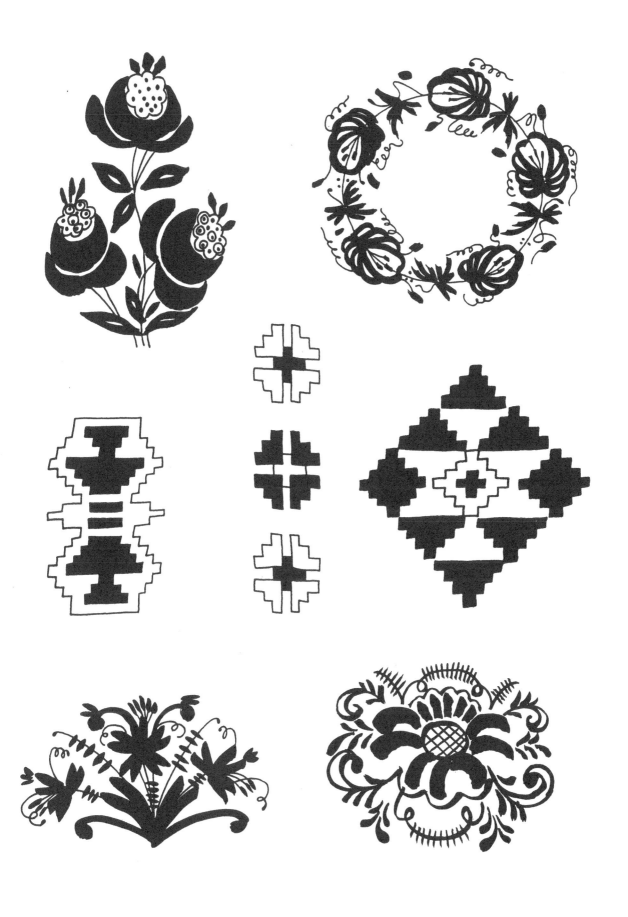

TOP: Ceramic motifs, Gzhel, 20th century. MIDDLE: Carpet motifs, Moldova, 19th century.
BOTTOM: Ceramic motifs, Gzhel, 20th century.

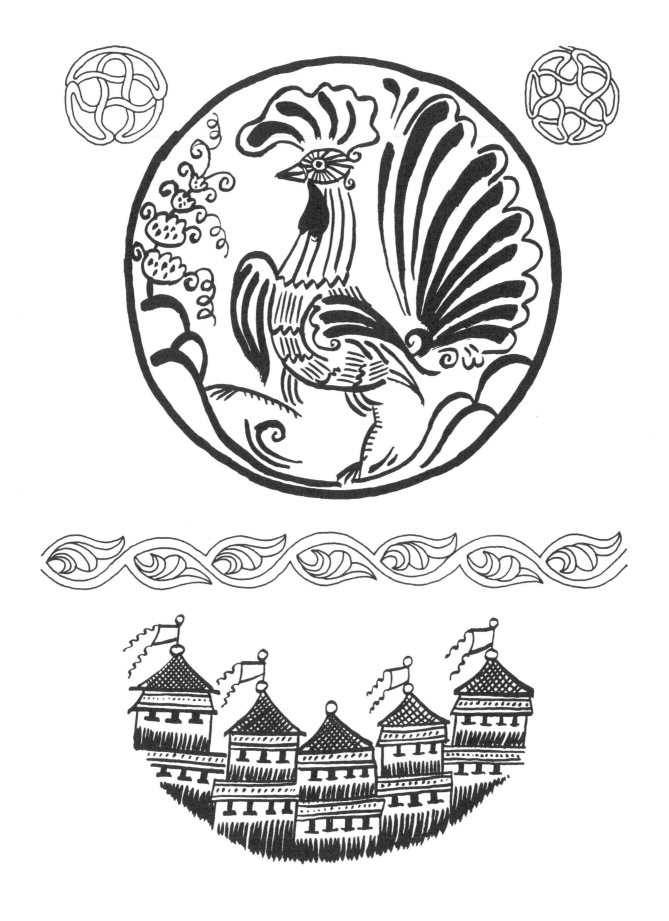

TOP, LEFT AND RIGHT: Altar screen motifs, Georgia, 10th century. TOP, CENTER: Ceramic motif, Gzhel, 20th century. MIDDLE: Architectural motif, Georgia, 5th century. BOTTOM: Ceramic motif, Gzhel, 18th century.

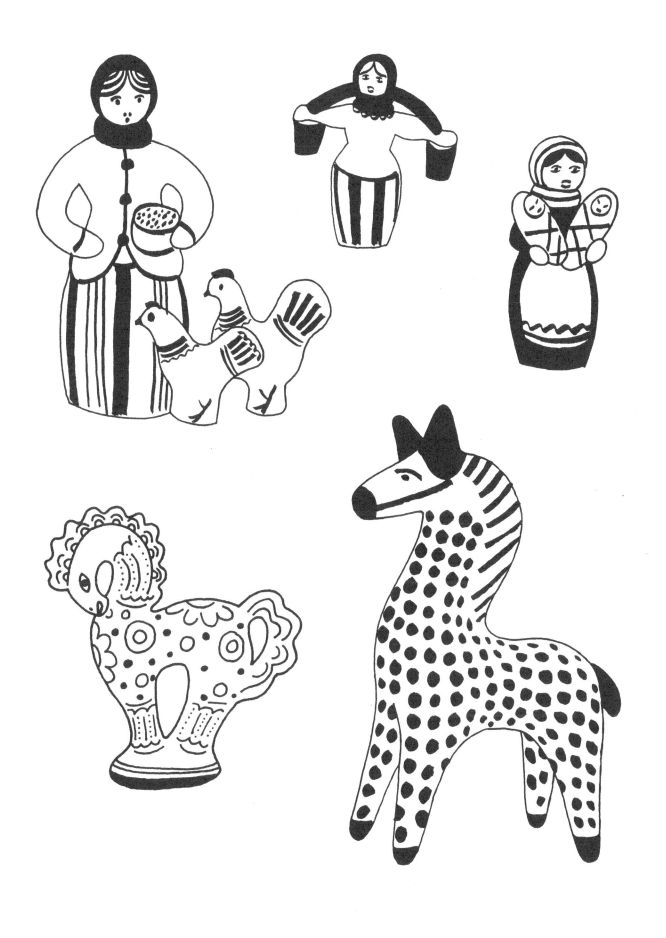

TOP: Ceramic figurines, Gzhel, 20th century. BOTTOM, LEFT: Ceramic figurine, Gzhel, 20th century. BOTTOM, RIGHT: Clay toy, Dymkovo, 20th century.

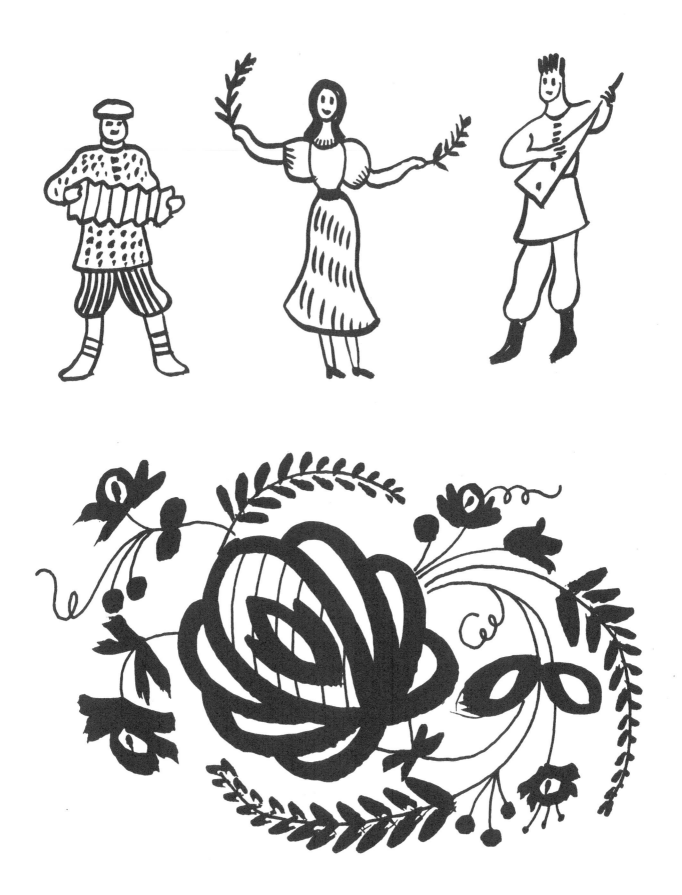

Ceramic motifs, Gzhel, 20th century.

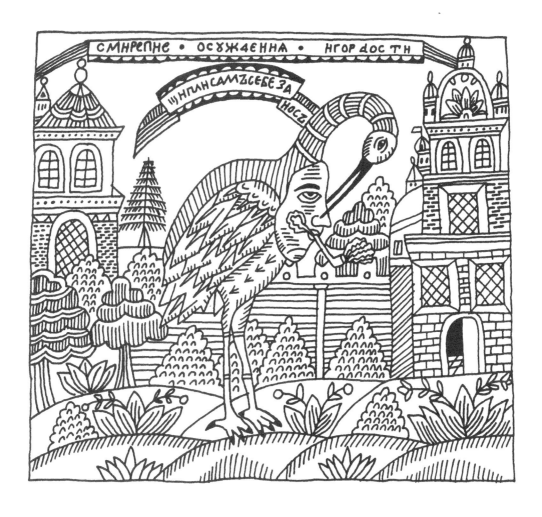

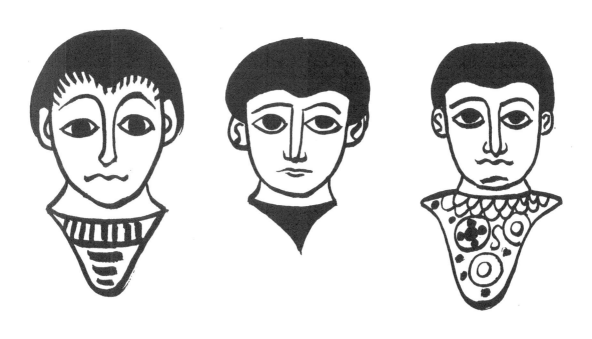

TOP: "Pinch-Your-Own-Nose," woodcut, 18th century. BOTTOM: Altar screen paintings, Georgia, 9th century.

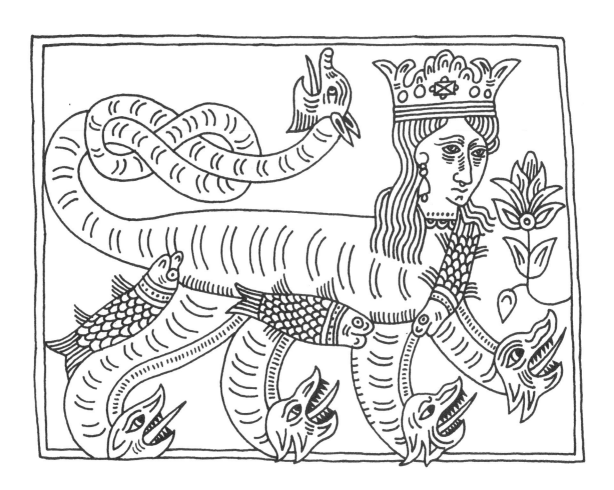

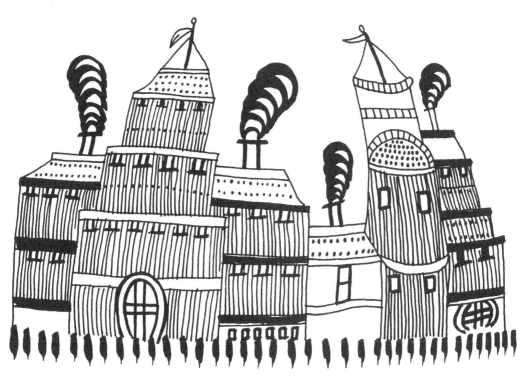

TOP: "The Melusine Fish Lives in the Ocean Near the Ethiopian Gorge," woodcut, 18th century. BOTTOM: Ceramic motif, Gzhel, 18th century.

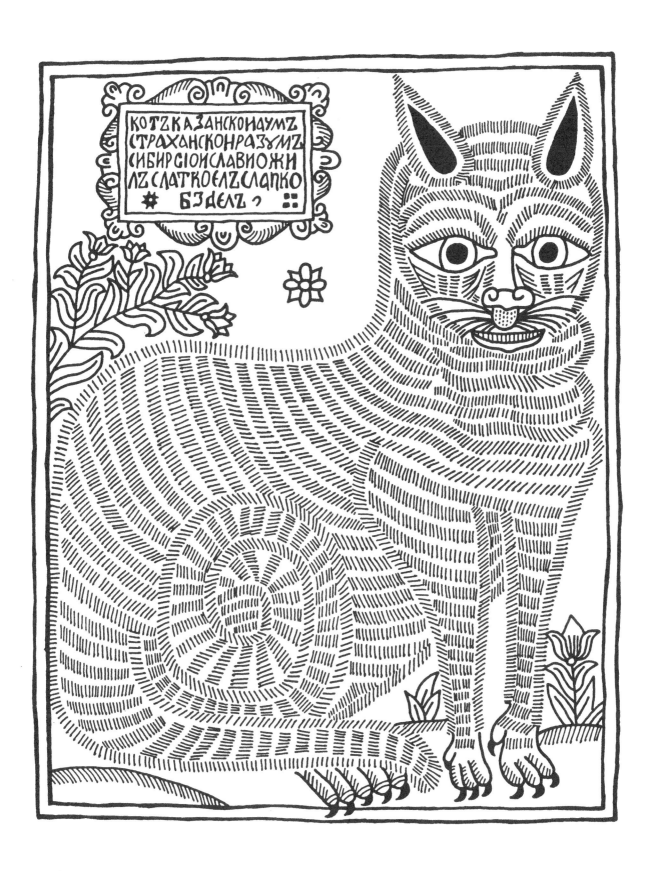

"The Cat of Kazan," woodcut, Moscow, 18th century.

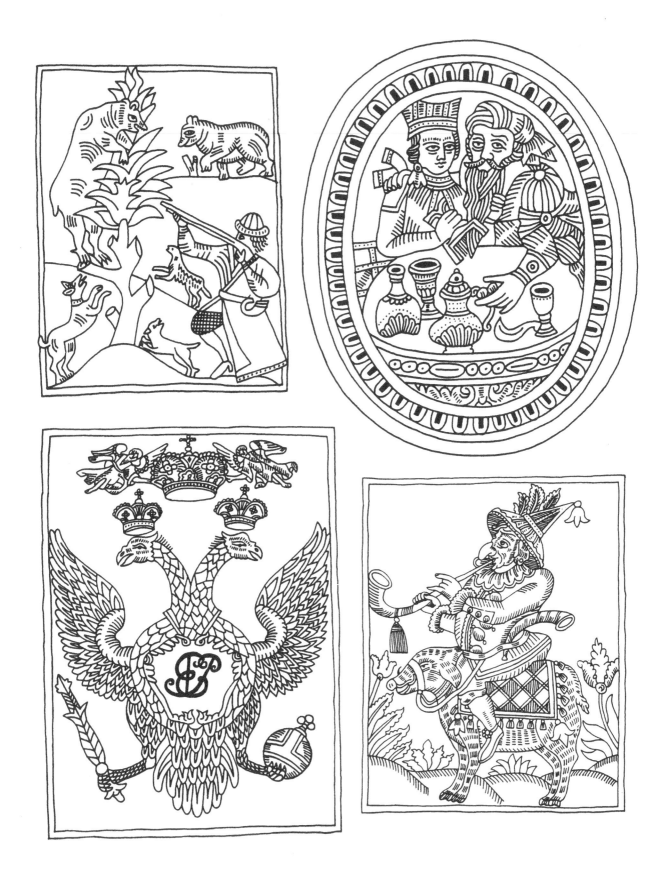

TOP, LEFT: "The Hunter Shoots the Bear," woodcut, Moscow, 18th century. TOP, RIGHT: "Eralach the Fool and the Girl," woodcut, Moscow, 18th century. BOTTOM, LEFT: Arms of the Empress Elizabeth Petrovna, woodcut, 18th century. BOTTOM, RIGHT: "Farnos the Fool on a Pig," woodcut, 18th century.

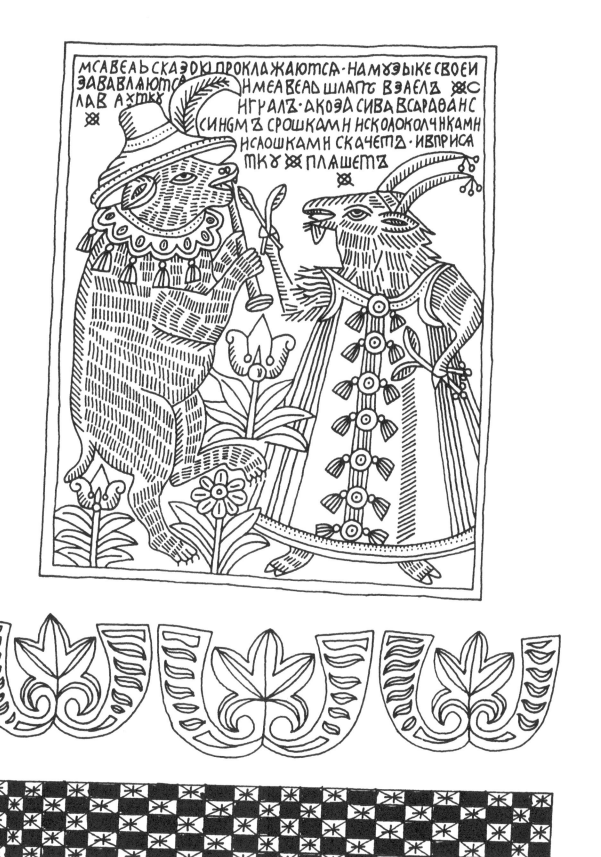

TOP: "The Bear and the Goat Entertain Themselves," woodcut, 18th century. CENTER: Architectural motif, Georgia, 5th century. BOTTOM: Ceramic motif, Gzhel, 19th century.

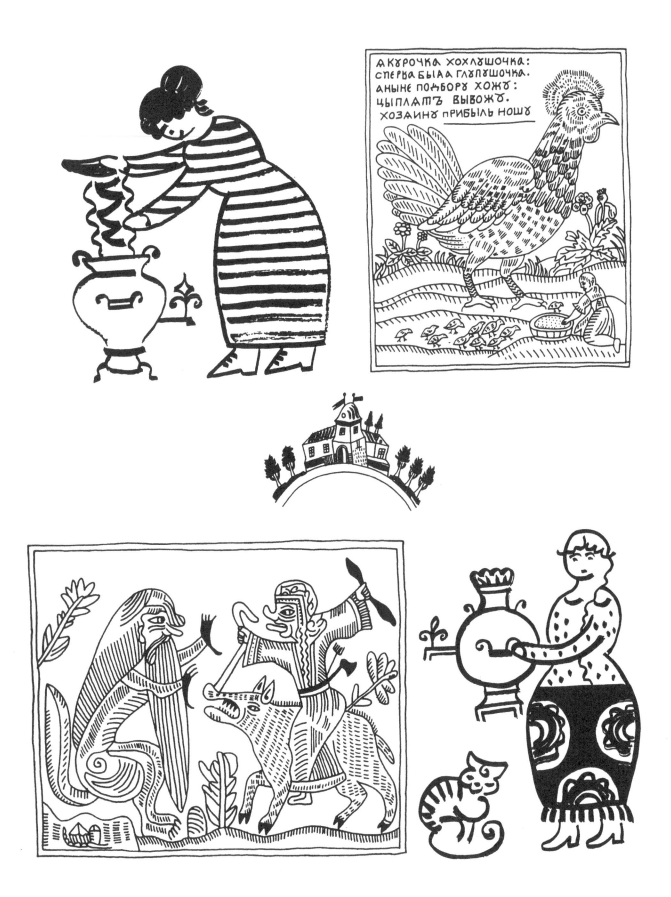

АКУРОЧКА ХОХЛУШОЧКА:
СПЕРВА БЫЛА ГЛУПУШОЧКА.
АНЫНЕ ПОДБОРУ ХОЖУ:
ЦЫПЛАТЪ ВЫВОЖУ.
ХОЗАИНУ ПРИБЫЛЬ НОШУ

TOP, LEFT: Ceramic motif, Gzhel, 20th century. TOP, RIGHT: "Mother Hen," woodcut, 18th century. MIDDLE: Ceramic motif, Gzhel, 19th century. BOTTOM, LEFT: "Baba-Yaga on a Pig Fights the Crocodile," woodcut, 18th century. BOTTOM, RIGHT: Ceramic motif, Gzhel, 20th century.

ROW 1: Architectural motif, Volga region, 19th century. ROW 2: Painted motif, Khokhloma, 20th century. ROWS 3–5: Ceramic motifs, Gzhel, 19th–20th centuries.

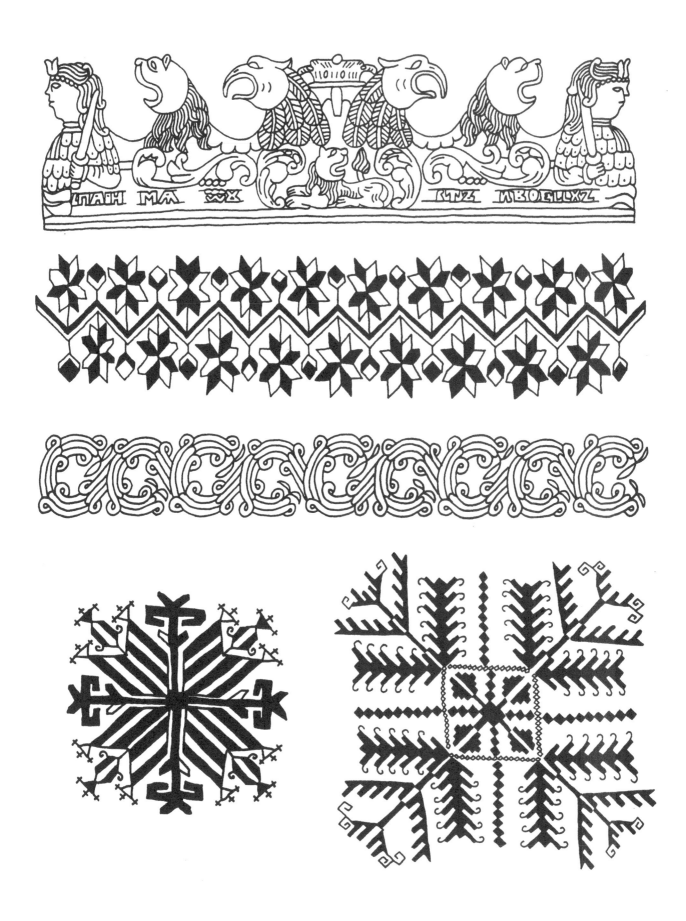

ROW 1: Ivory comb motif, 17th century. ROW 2: Carpet motif, Moldova, 19th century. ROW 3: Architectural motif, Georgia, 5th century. ROW 4: Embroidered motifs, 19th century.